REMEMBERING NOTRE DAME

PART I: The Dome (and the God Quad)

Michael D. Ciletti '64, '65, '68

REMEMBERING NOTRE DAME
Part 1: The Dome (and God Quad)

Copyright © 2012 Michael D. Ciletti

ISBN 978-0-9833586-1-9

ACKNOWLEDGMENT: The author is pleased to acknowledge the resource used for the historical information cited in this book: T.J. Schlereth, The University of Notre Dame: A Portrait of Its History and Campus, University of Notre Dame Press, 1976.

Prints of Images: Over four hundred images of the campus, including those presented in Remembering Notre Dame, may be ordered as individual prints in formats and sizes suitable for framing. See the web site: www.mdcimages.com for details.

Published by
Corby Books
A Division of Corby Publishing LP
P.O. Box 93
Notre Dame, Indiana 46556
(574) 784-3482
www.corbypublishing.com

Manufactured in the United States of America

Dedication

This book is dedicated to the memory of Fr. Jerome J. (Jerry) Wilson, C.S.C. (1911-1998). Fr. Jerry, as he was known, graduated in 1932 and, after a period in the business world, returned to Notre Dame to enter the Congregation of Holy Cross. He served the University from 1949 until 1978, where he taught accounting from 1949 to 1952, directed the Old College Seminary Program from 1951-52, was vice-president of Business Affairs from 1952 to 1976, and was the executive administrator of the physical plant from 1976-78. Many were touched by his warmth, love, and friendship—and especially by his priesthood. He was a confessor to some, a father figure to others, and a mentor to seminarians at Moreau Seminary (1979-1998). He loved spaghetti and playing bridge, and was a gracious guest in our homes. Our lives were blessed by him. He loved Notre Dame, and his love inspired others to a deeper appreciation of this great University.

Introduction

Remembering Notre Dame is a "memory" book. It's meant to go home with you and help you recall the sights, sounds, and events that you enjoyed during your visit to the University of Notre Dame. Your experience of this beautiful and remarkable place is special. We hope that our presentation of images of the campus will stir fond memories for you and will sow the seeds that lead you to return to discover and experience even more of its beauty.

This is also a "place" book, meant to help you recall the enjoyment of being here at Notre Dame. Notre Dame is a place and a people—a family. We hope that this presentation of places will be a key that unlocks memories of the people that have made Notre Dame special for you.

This first of three volumes presents images primarily of the structures comprising the historic, central core of the campus. Its companion volumes present images depicting a broader view of the life, learning, and athletic drama that animate the campus.

The University of Notre Dame was founded on snow-covered land in Northern Indiana on November 24, 1842, by Fr. Edward Sorin, a 28-year-old priest of the Congregation of Holy Cross (C.S.C.). Fr. Sorin dedicated the University to Our Lady and (later) officially named it the University of Notre Dame du Lac, i.e., Our Lady of the Lake. On that day Fr. Sorin did not know that the land actually had two lakes.

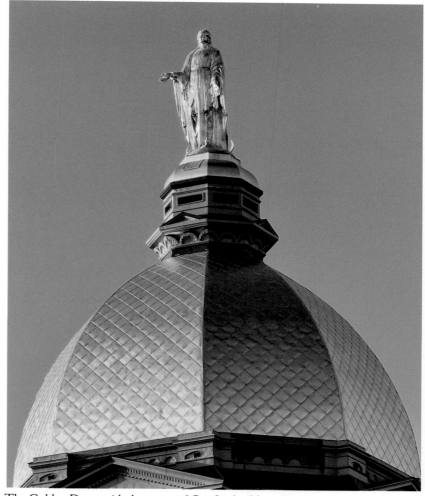

The Golden Dome with the statue of Our Lady (Notre Dame) is the most recognizable iconic landmark of the campus.

The main entrance to the campus greets us at the intersection of Notre Dame Avenue and Angela Boulevard. The sturdy monument there is relatively new—the trolley tracks are gone and the streetlights have changed to keep up with the times—but the walk to campus still takes us past Cedar Grove Cemetery and brings us through a canopy of maple trees.

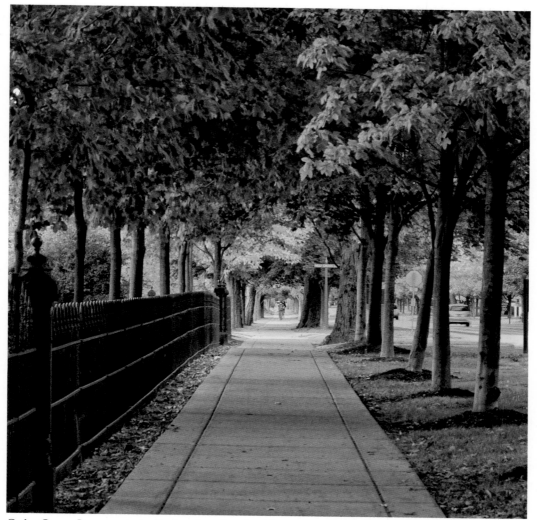

Cedar Grove Cemetery is the final resting place for Alexis Coquillard, a co-founder of the city of South Bend, who helped Fr. Sorin by providing financial support to the University in its early days. Faculty and friends of the University are among those buried here.

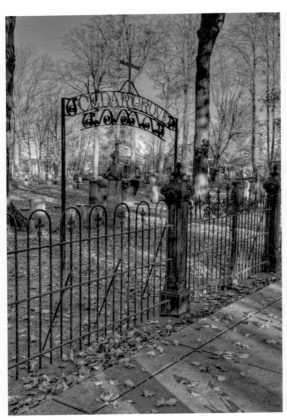

Entrance to Cedar Grove Cemetery

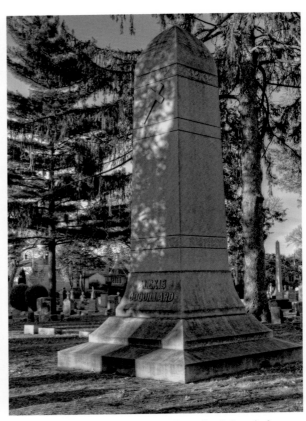

The monument honoring Alexis Coquillard dwarfs the tombstones in Cedar Grove Cemetery.

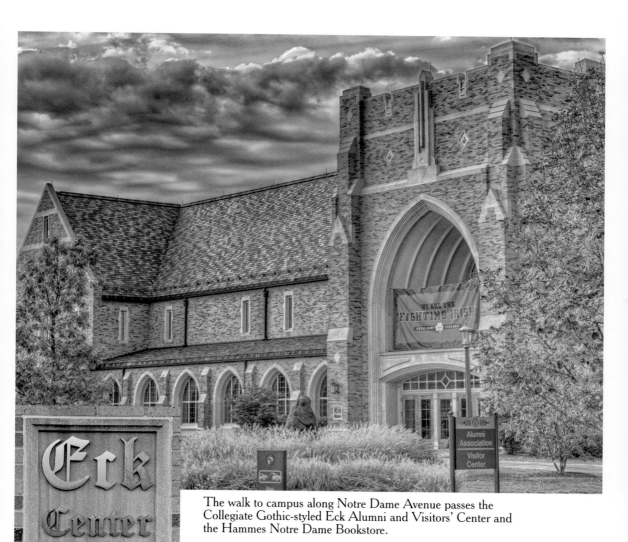

The walk to campus along Notre Dame Avenue passes the Collegiate Gothic-styled Eck Alumni and Visitors' Center and the Hammes Notre Dame Bookstore.

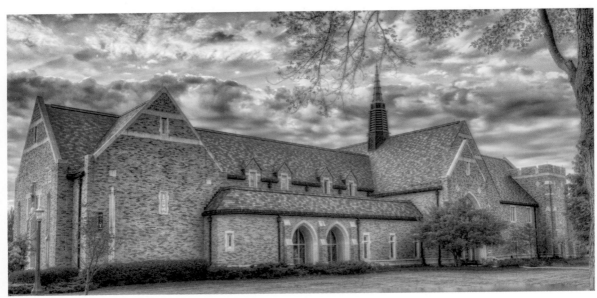

The Eck Alumni and Visitors' Center, viewed from Notre Dame Avenue

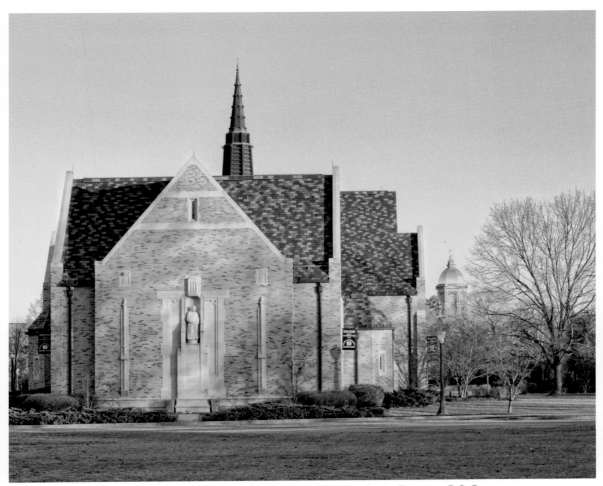

The south wall of the Eck Alumni and Visitors' Center honors Brother André Bessette, C.S.C.,
canonized a saint of the Roman Catholic Church in 2010.

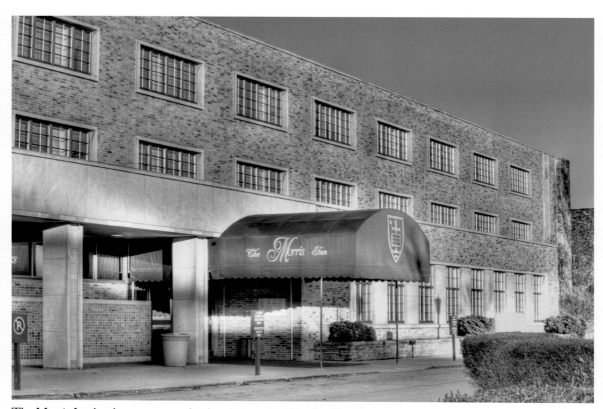

The Morris Inn has been a campus landmark since the '50s. It will undergo a renovation and expansion beginning in the fall of 2012.

The statue of Notre Dame (Our Lady) stands at "The Circle," where northbound cars approaching the campus make a loop to exit southbound via Notre Dame Avenue. The Circle is a meeting place for students coming to and going from campus, and for parents meeting students. A bus shelter and guard house stood nearby during the '60s, joined eventually by yet another relocation of the campus post office. Later expansion and reconfiguration of the campus have removed those structures, but the Circle is still there and the statue of Our Lady still greets us.

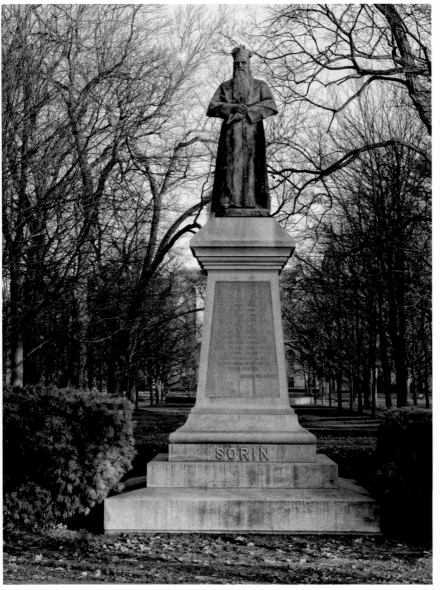

The statue of Fr. Edward Sorin, C.S.C., founder of the University, marks what students refer to as the "God Quad"—the tree-shaded area immediately in front of the Main Building—which also leads to the Basilica of the Sacred Heart. As you walk towards the Dome, you will reach the statue shortly after you pass the flagpole in the center of the quad.

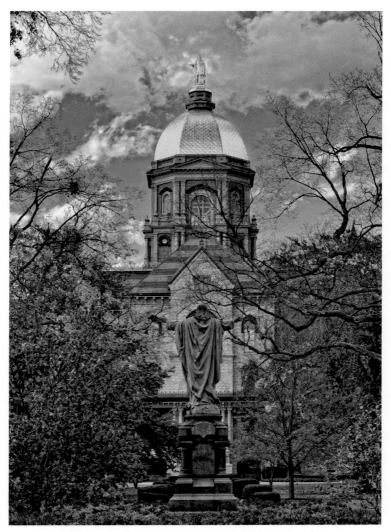

The Main Building houses the major administrative offices of the University. Here is where you will find the President's Office and the Office of Admissions. A statue of Christ (known by some as the original "Touchdown Jesus") faces the Main Building.

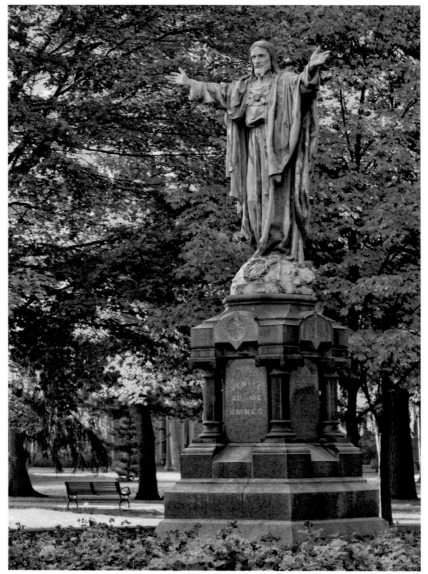

12 "Venite Ad Me Omnes" – Christ beckons all to come to Him.

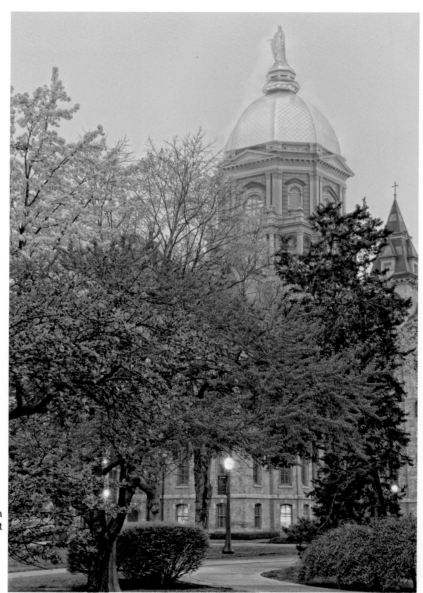

Spring blossoms and the Dome in
early morning light

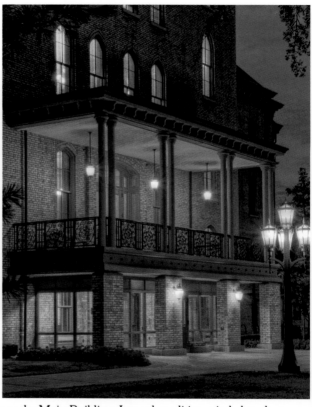

By tradition, students do not use the steps at the entrance to the Main Building. Instead, tradition-minded students use the ground-level entrance beneath the front porch or they enter at the back of the building. Graduates are welcome to use any entrance!

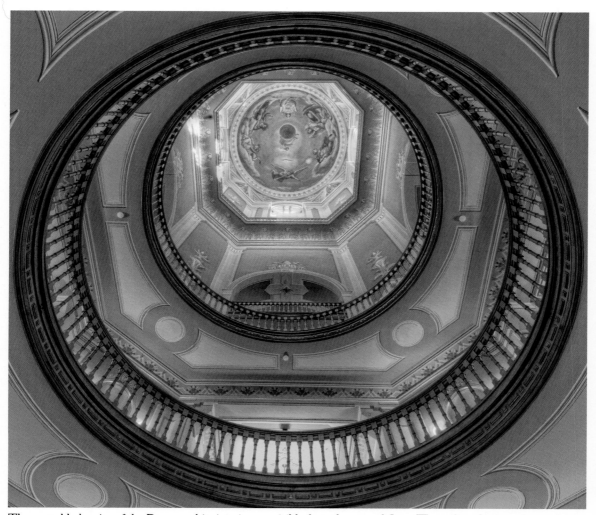

The nested balconies of the Dome and its interior are visible from the second floor. The ceiling depicts a heavenly scene; and trumpeters serenade from the balconies on football Saturdays.

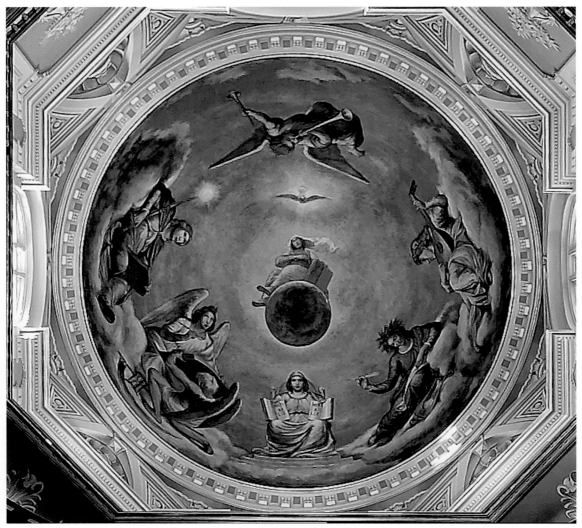

Close-up of the interior ceiling of the Dome: The characters in Luigi Gregori's painting represent Religion (central figure, facing south), Philosophy, History, Science, Fame, Music, and Poetry (counter-clockwise).

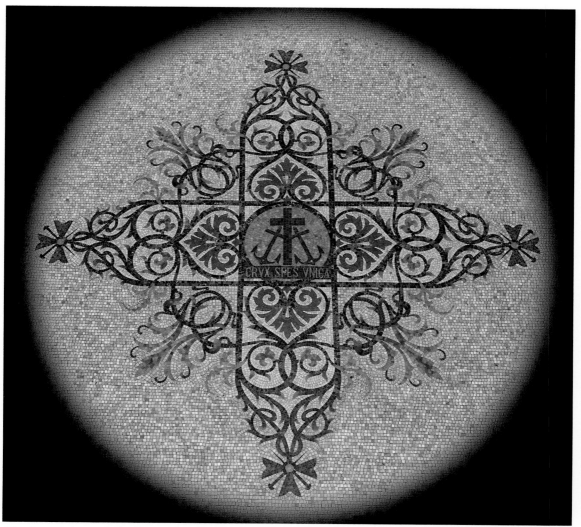

The floor underneath the Dome (actually the second floor of the Main Building) holds the "Crux Spes Unica" logo of the Congregation of Holy Cross and proclaims its motto: "The cross – our only hope."

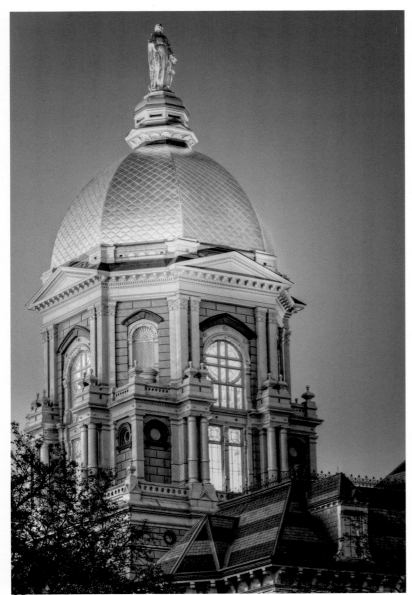

The remarkable golden panels
of the Dome glisten in
the evening light.

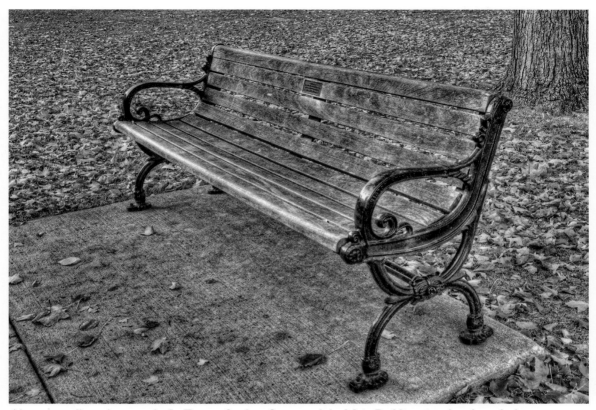

Along the walkway between the LaFortune Student Center and the Main Building sits a bench marked by a small plaque that reads: "Field office of our Beloved Professor of Chemistry and Dean of First Year of Studies, Dr. Emil T. Hofman."

Dr. Hofman's enduring and endearing legacy began in the '60s, when he was a grad student-instructor in the chemistry labs. Lore about him includes his reputation for filling a chalkboard with one hand and following behind with an eraser. His fame grew and, eventually, students followed a band and chanted their way to his exams. Many students discovered the fear of God in his lectures.

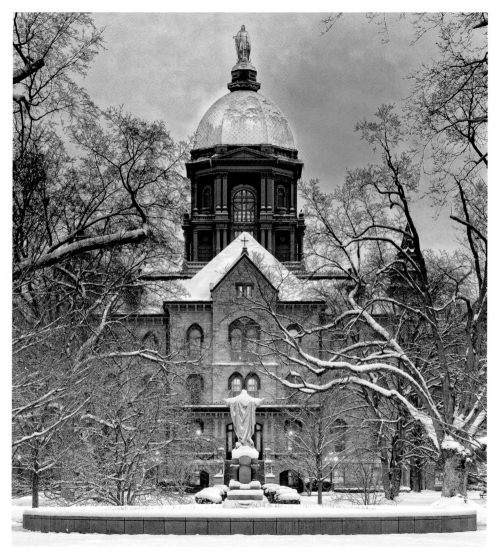

The Golden Dome is spectacular all year-round, in any weather. The Main Building, with a redesigned Dome, was rebuilt in 1879—immediately after a fire of unknown cause destroyed the original building.

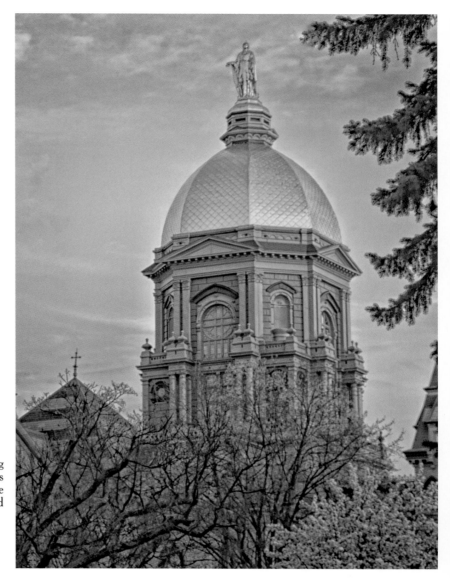

The Dome, in early morning
light, with spring blossoms
emerging on the trees in the
God Quad

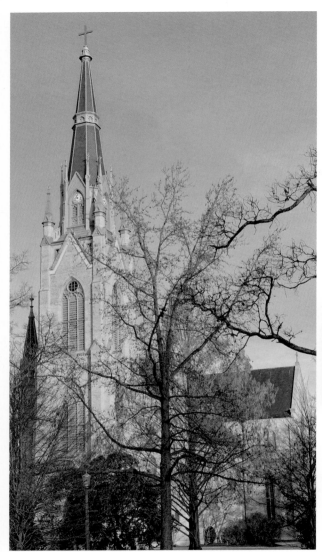

Located beside the Main Building, the Basilica of the Sacred Heart anchors the spiritual life of the University.

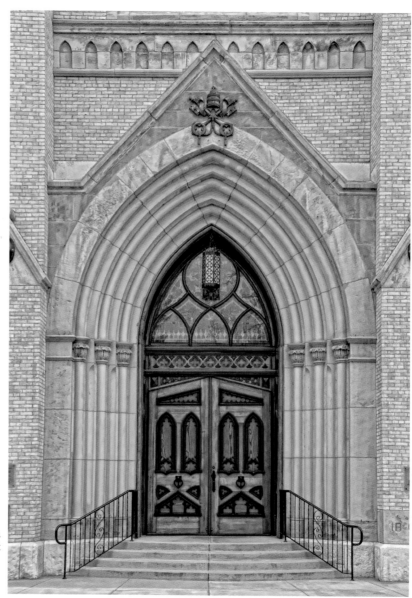

Main entrance to the Basilica
of the Sacred Heart

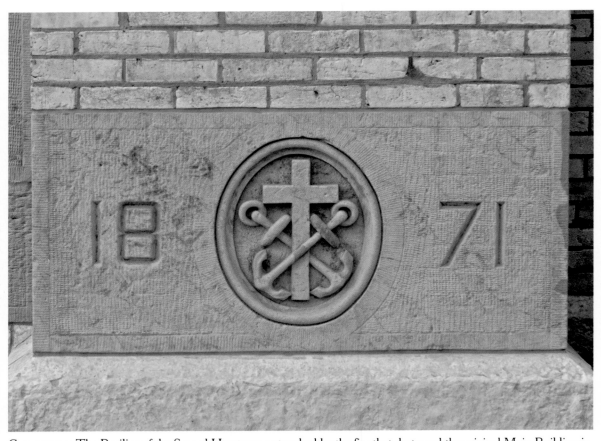

Cornerstone: The Basilica of the Sacred Heart was untouched by the fire that destroyed the original Main Building in 1879.

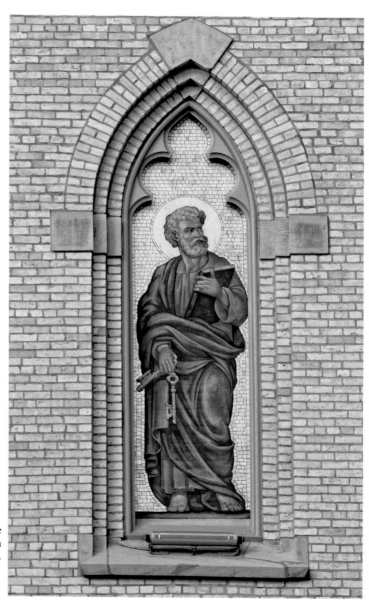

A mosaic of St. Peter graces the side entrance (west of the main entrance) to the Basilica.

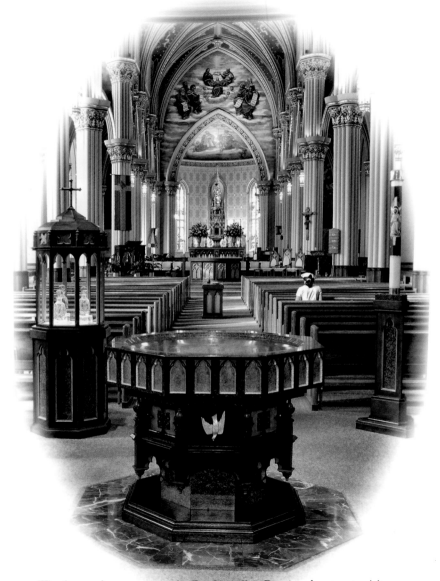

The font at the entrance to the Basilica offers Baptismal waters to visitors.

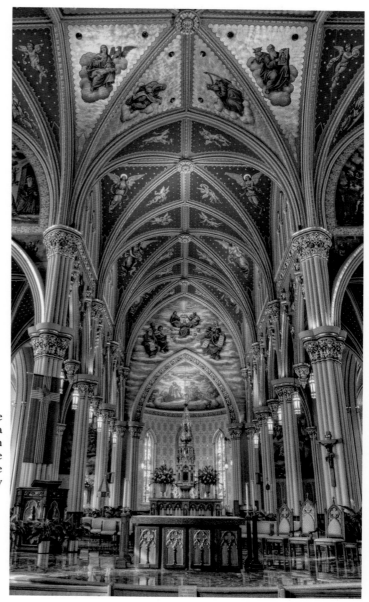

The main altar of the Basilica, beneath a ceiling adorned with the gold and blue colors of the University

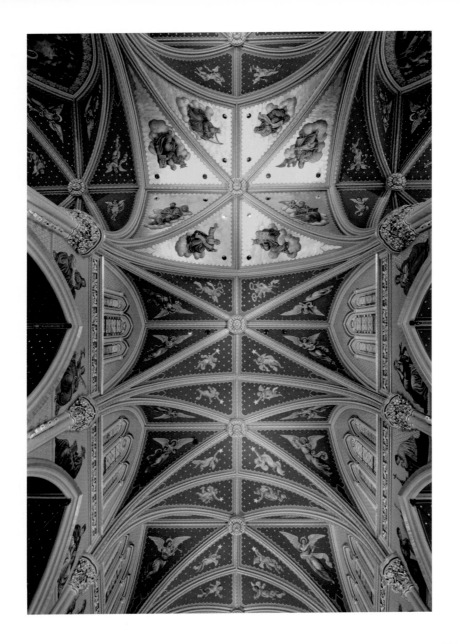

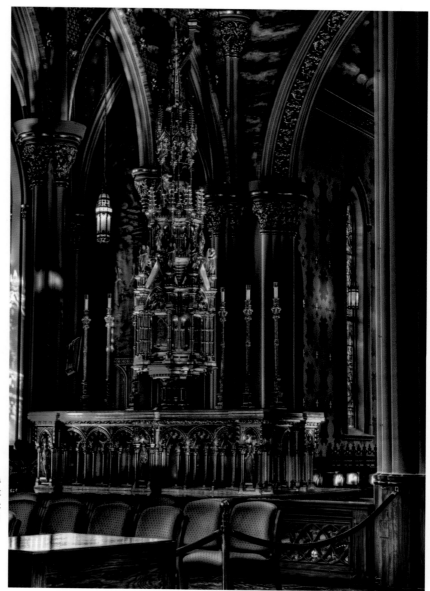

Main altar of the Basilica
of the Sacred Heart
(rendered with artistic
license)

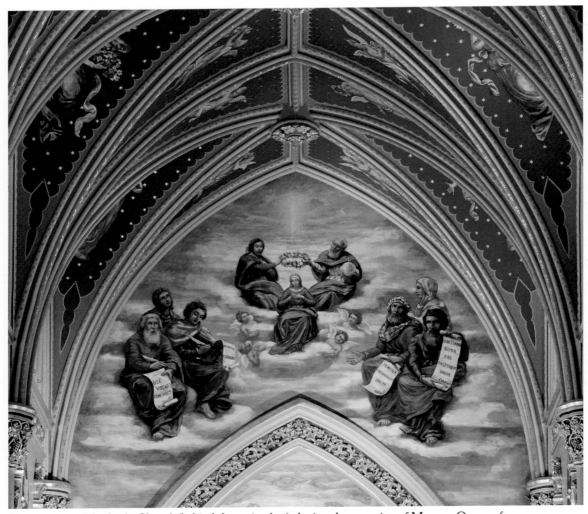

The painting of the Lady Chapel (behind the main altar) depicts the crowning of Mary as Queen of Heaven and Earth.

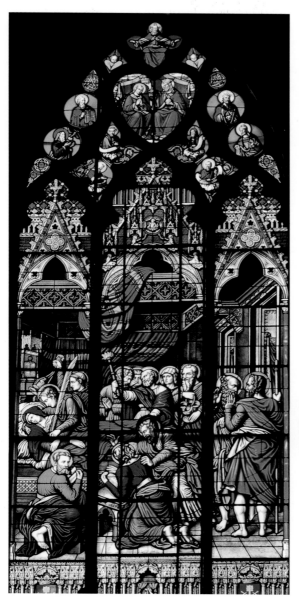

Rich in color and detail, the stained-glass window at the west transept depicts the death of Mary, with the Apostles. It is the largest in the Basilica.

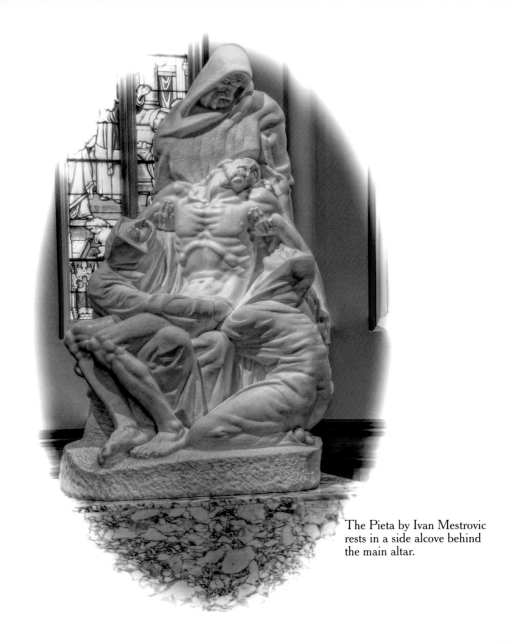

The Pieta by Ivan Mestrovic rests in a side alcove behind the main altar.

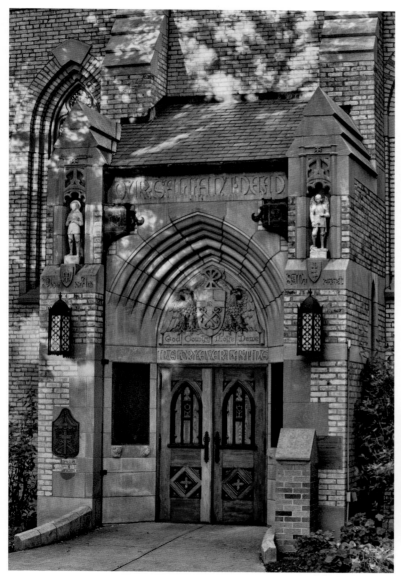

At the east transept entrance to the Basilica, the so-called "God, Country, and Notre Dame" door honors "Our Gallant Dead in Glory Everlasting." Reliefs of WW-I soldiers and a nurse grace the side walls, along with plaques naming and honoring those graduates who gave their lives in battle for our country.

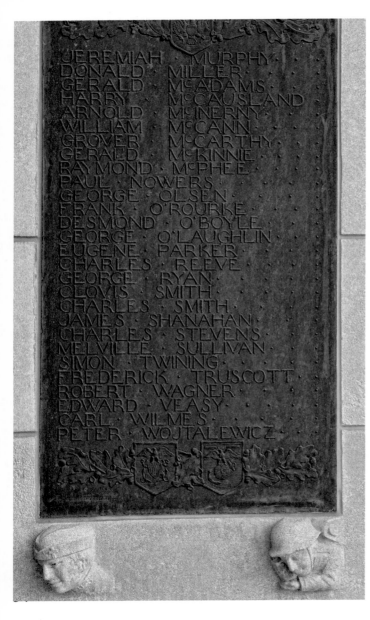

Our gallant dead of World War I.

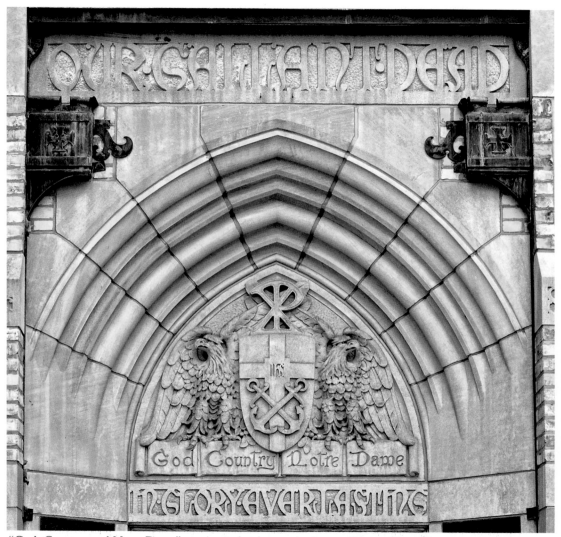

"God, Country, and Notre Dame"— a reminder that service is a tradition at Notre Dame

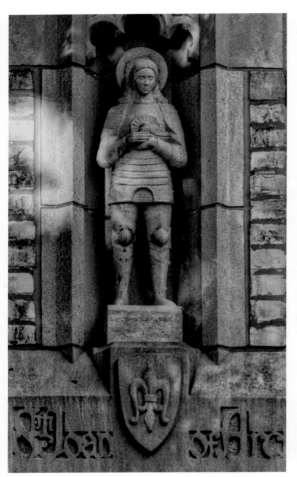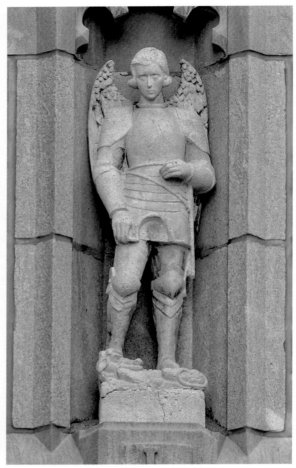

St. Joan of Arc and St. Michael the Archangel overlook the door at the east transept of the Basilica.

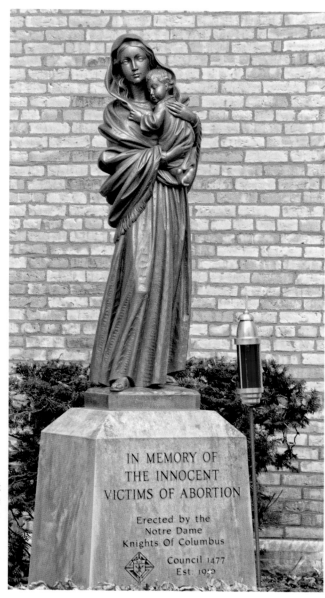

Beside the east transept
stands a reminder of the
sacred value of life.

IN MEMORY OF
THE INNOCENT
VICTIMS OF ABORTION

Erected by the
Notre Dame
Knights Of Columbus

Council 1477
Est. 1909

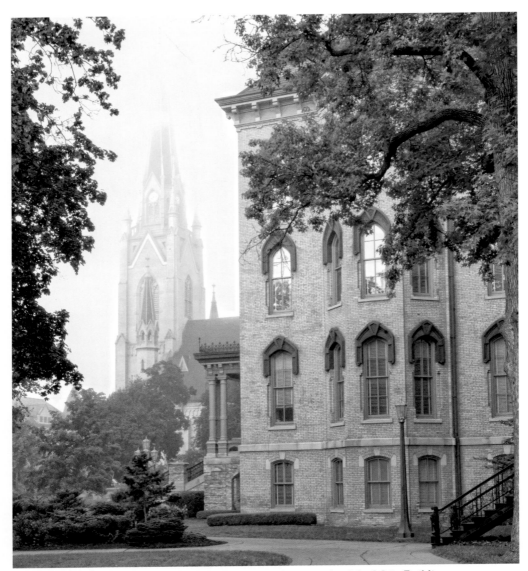

The Basilica, shrouded in morning mist, viewed from the east side of the Main Building

Corby Hall, a residence for priests, is located immediately to the west of the Basilica.

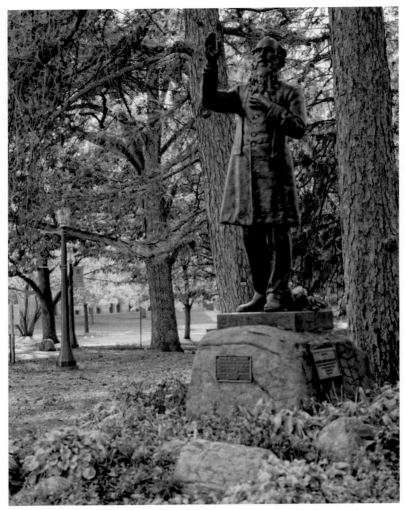

Corby Hall is named for Fr. William Corby, C.S.C., the chaplain for the Irish Brigade at the Battle of Gettysburg. He later served as president of the University. This statue is also known as "Fair Catch Corby."

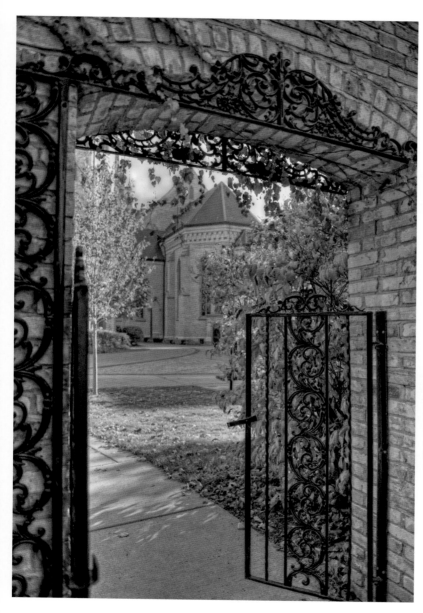

Behind the Main Building, a tiny courtyard is nestled between Brownson Hall and the Nanovic Institute for European Studies. A visitor leaving the courtyard through this gate finds a special view of the Basilica.

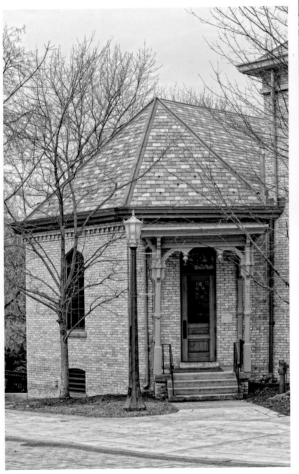

The buildings immediately behind the Basilica are the second-oldest buildings on campus. At the turn of the century, they housed the University kitchens and a chapel for the Sisters of the Holy Cross. Nearby was Brownson Hall, where Fr. Bernard Lange maintained his gym for bodybuilding.

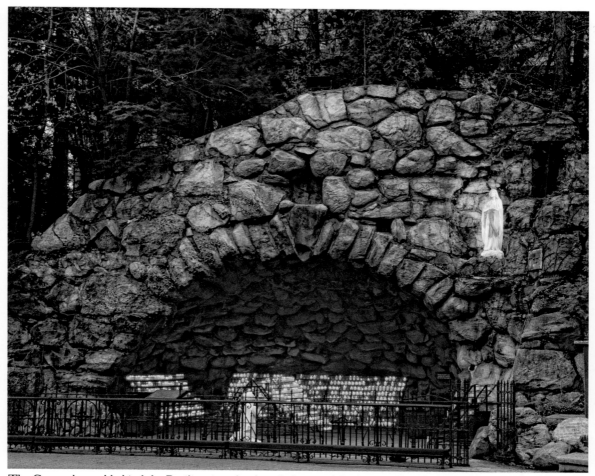

The Grotto, located behind the Basilica, is a closely styled copy of the famous Grotto at Lourdes, France. Generations of students have come here to pray for grades, family, and friends. Parents bring children here to pray—and sometimes to drink from the triangular fountain. Some would say that a visit to Notre Dame is not complete without lighting a candle at the Grotto.

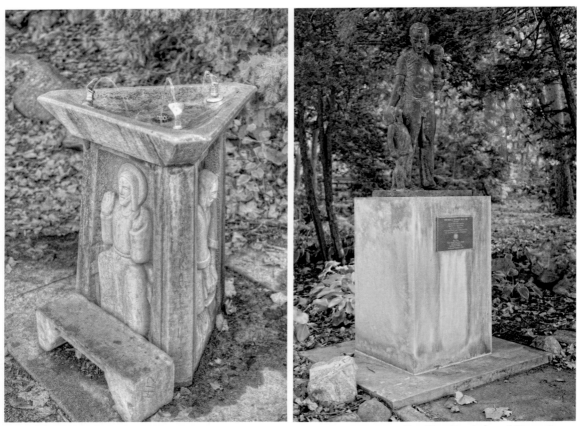

The walkway to the Grotto from behind Corby Hall leads past a statue honoring Dr. Tom Dooley, an ND graduate and physician who served the people of Viet Nam before succumbing to cancer in 1961.

"... [I]f I could go to the grotto now, then I think I could sing inside. I could be full of faith and poetry and loveliness and know more beauty, tenderness, and compassion."
– Dr. Tom Dooley, quoted from the *Dome* (yearbook) 1961

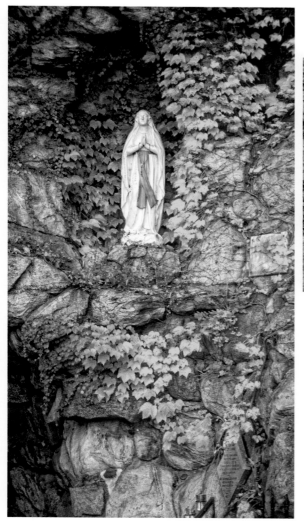

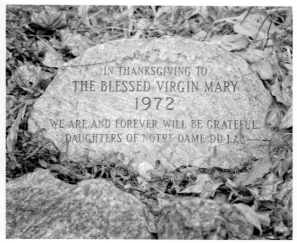

"IN THANKSGIVING TO
THE BLESSED VIRGIN MARY
1972
WE ARE AND FOREVER WILL BE GRATEFUL
DAUGHTERS OF NOTRE DAME DU LAC"

The historic core of the campus includes Sorin, St. Edward's and Walsh residence halls. St. Edward's Hall, built in 1888 as the University's grade school, stands at the northeast corner of the Main Building. Here, bicycles gather snow at the entrance to St. Ed's. Bicycles are almost essential to students needing to travel the greatly expanded geography of the campus buildings and athletic fields.

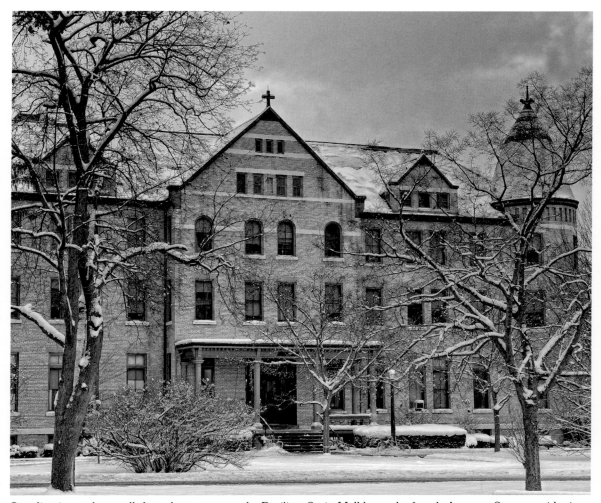

Standing just a short walk from the entrance to the Basilica, Sorin Hall bears the founder's name. Some consider it to be the most prestigious and desirable men's dorm.

Walsh Hall is now a dorm for women. It marks the west side of the God Quad. It is adjacent to the south side of Sorin Hall.

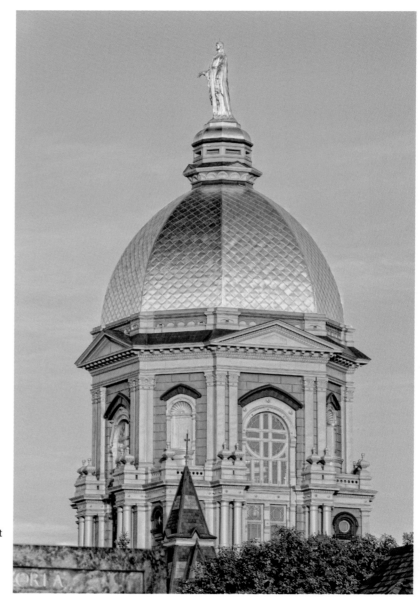

The Dome in morning light

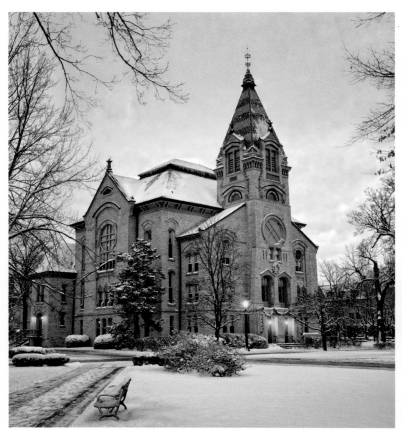

Washington Hall, east of the Main Building, was the only venue for plays and other performances until the DeBartolo Performing Arts Center was built. The activities of football weekends begin here, with the band stepping off at 3 p.m. on Friday afternoon.

Main entrance to the LaFortune
Student Center –
"Mixers" were held here in the
'60s to bring together Notre Dame
students with those from St. Mary's
College, Mundelein College, and
Barat College. The basement has
been reconfigured over the years;
today it houses a travel agency, a copy
center and other small
commercial venues.

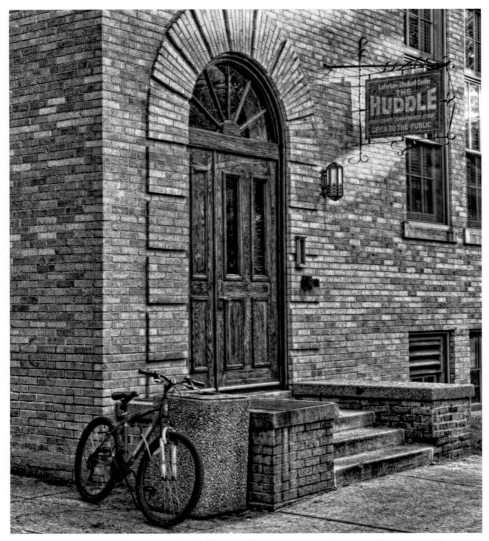

The Huddle, which is located in the LaFortune Student Center, has been "re-invented" many times—from a small soda fountain/grill in the '60s to its present configuration, housing fast-food outlets, dining areas, and a small convenience store.

The Navy Drill Hall, the Fieldhouse, a TV/radio station, and WWII-era housing for married students once stood east of the LaFortune Student Center. In 1963 they were demolished to make room for the Hesburgh Memorial Library. The cornerstone of the Fieldhouse, which is all that remains of the original structures, faces the east entrance of the LaFortune Student Center.

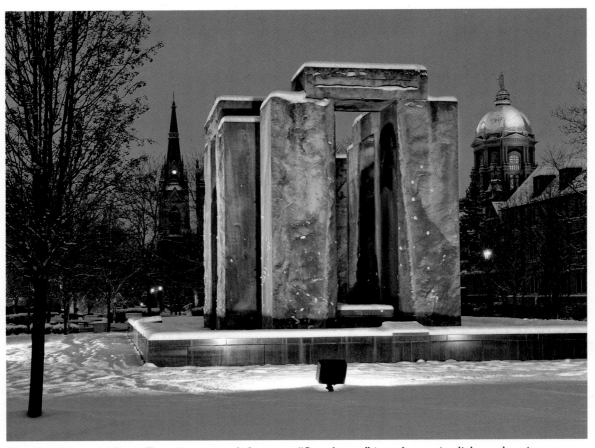

The Clark Memorial Peace Fountain, commonly known as "Stonehenge," in early morning light, under winter snow: It honors our veterans of World War II, Korea, Viet Nam, and others in peacetime service to our country.

The Crowley Hall of Music is next to the LaFortune Student Center in the God Quad. It formerly housed the architecture program.

Beginning at the Grotto, the road from Notre Dame to St. Mary's is well traveled.

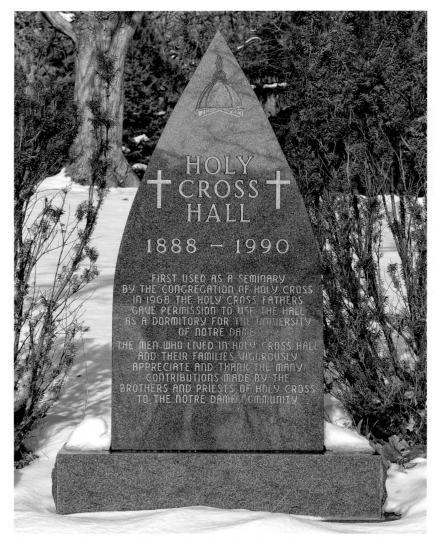

HOLY ✝ CROSS ✝ HALL

1888 – 1990

FIRST USED AS A SEMINARY
BY THE CONGREGATION OF HOLY CROSS
IN 1968 THE HOLY CROSS FATHERS
GAVE PERMISSION TO USE THE HALL
AS A DORMITORY FOR THE UNIVERSITY
OF NOTRE DAME

THE MEN WHO LIVED IN HOLY CROSS HALL
AND THEIR FAMILIES VIGOROUSLY
APPRECIATE AND THANK THE MANY
CONTRIBUTIONS MADE BY THE
BROTHERS AND PRIESTS OF HOLY CROSS
TO THE NOTRE DAME COMMUNITY

A granite marker on the hill above St. Mary's Lake marks the site where Holy Cross Hall served as the seminary for the priests of the Holy Cross Order for over 100 years.

Old College has had many uses since its construction in 1843. It now houses students who are discerning a vocation to the priesthood.

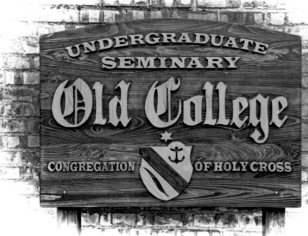

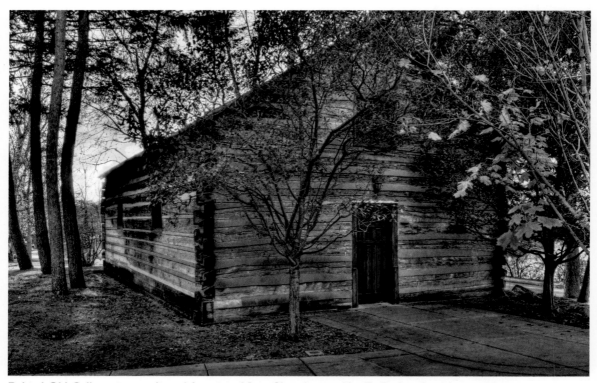
Behind Old College sits a replica of the original Log Chapel erected by Fr. Badin. Countless weddings have been celebrated (and engagements solemnized) in the Log Chapel.

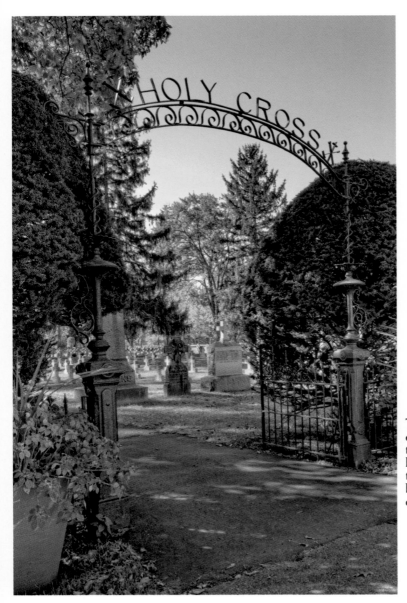

The gated entrance to Holy Cross Cemetery is found along the road between the Grotto and St. Mary's College. This holy ground is the final resting place for the priests and brothers who founded, built, and served the University and/or other Holy Cross ministries.

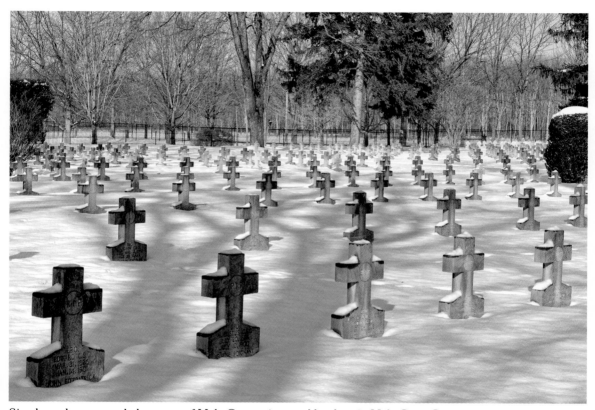
Simple tombstones mark the graves of Holy Cross priests and brothers in Holy Cross Cemetery.

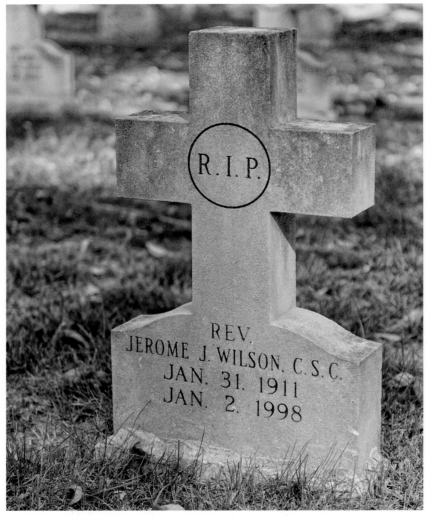

Here we see the tombstone of Fr. Jerry Wilson, C.S.C., to whom this book is dedicated. Fr. Jerry served Notre Dame as Vice President of Business Affairs. A beloved priest, he touched the lives of many students and friends of the University and their families.

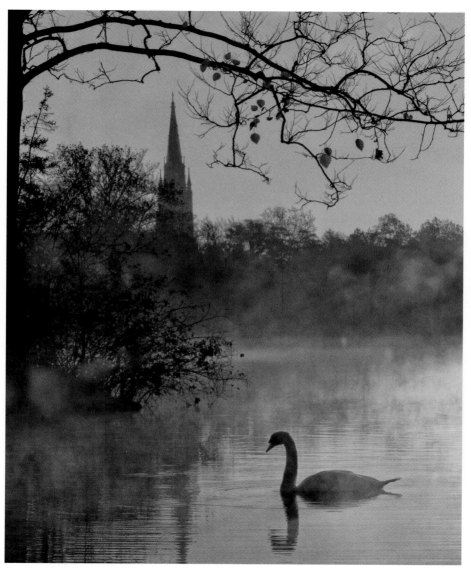

A swan in the morning mist at St. Mary's Lake enjoys the warmth of the rising sun.

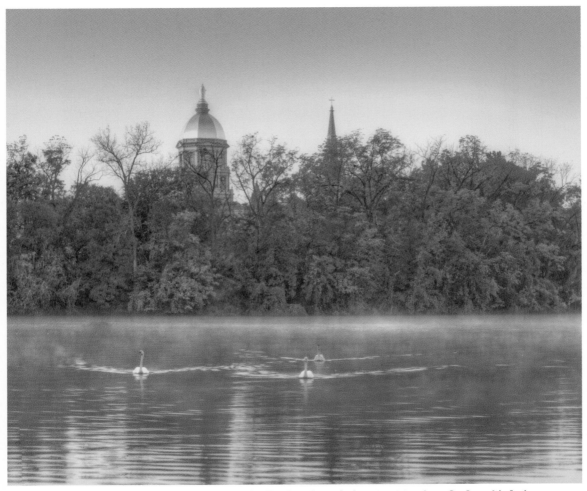

Early risers might catch a view of the Dome and the Basilica through the mist rising from St. Joseph's Lake.

The path around St. Mary's Lake winds past Carroll Hall, formerly used to house preparatory students, now serving as a residence hall. Its residents refer to themselves as "The Vermin."

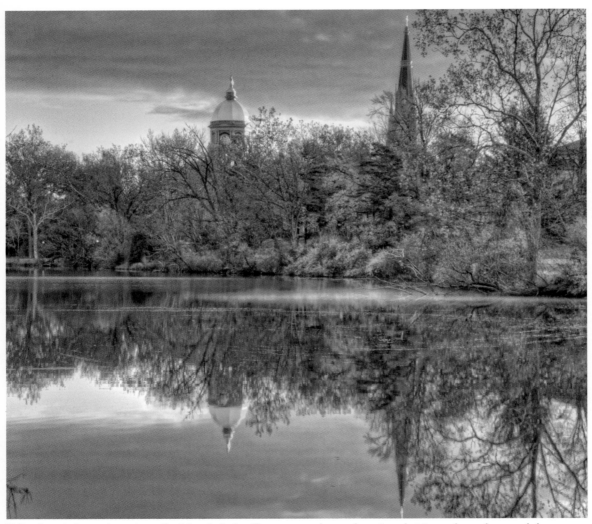

Fall colors and morning mist at St. Mary's Lake: For many students, alumni, and visitors, the path around the lakes is a favorite for running, walking, and enjoying solitude.